A Catalog to Accompany an Exhibit at the
Chemical Heritage Foundation of the
Herbert H. and Grace A. Dow Foundation's
Collection of the Art Works of
Arthur Henry Knighton-Hammond

Dow Chemical Portrayed

Gina Frese

Chemical Heritage Foundation
Philadelphia, Pennsylvania

D1262514

Exhibit sponsored by the Midland County Historical Society of the Midland
Center for the Arts, Inc.

Printed in the United States of America.

Book designed by Mark Willie, Willie•Fetchko Graphic Design
Printed by Piccari Press, Inc.
Photographs of Arthur Knighton-Hammond's works by Will Brown

A CIP catalog record for this book is available from the Library of Congress.

ISBN 0-941901-26-2

This book is printed on acid-free paper.

Contents

Preface

In the early decades of the twentieth century America's chemical industry grew to a robust first maturity. Abundant natural resources, growing domestic markets, a steady supply of educated, energetic entrepreneurs—these, together with the shock treatment afforded by World War I, were more than sufficient to guarantee that the American chemical enterprise would truly come into its own. Chemical plants, innovative processes, and personal fortunes all grew on a scale befitting the scope of the American experience. No company or individual exemplified and contributed to these new realities more than The Dow Chemical Company and Herbert Henry Dow.

Herbert Dow's desire to capture on canvas the company that he had built was characteristic of the man. The Dow Chemical Company's success flowed from its founder's practical zeal. He was a sagacious marketer as well as an innovative chemist. Paintings on canvas offered just one more way to express the larger meaning of his enterprise. His 1920 commission to Arthur Henry Knighton-Hammond followed both European and American precedents, while providing a creative, artistic way to capture the scale of Dow's enterprise and promote its proliferating services to the world.

This catalog and the exhibit that it accompanies offer a unique look into the American chemical industry in the first flush of a new maturity. Knighton-Hammond's visions of Dow Chemical and the town of Midland, Michigan, where it was headquartered, also fit into a continuing, great tradition of visual recordings of humankind's inventiveness, tenacity, and success.

Many individuals have given generously of their time, knowledge, effort, and resources to bring this undertaking to fruition. We extend our sincerest gratitude to Herbert D. (Ted) Doan and The Herbert H. and Grace A. Dow Foundation for the loan of the Knighton-Hammond works displayed in this exhibit. Others in Midland who gave generous help and support include Julie Arbury, E. N. (Ned) Brandt, Douglas J. Chapman, James J. Leddy, Gary Skory, Kathleen Thomas, and Bruce Winslow. We are also indebted to Peter Norris, on whose comprehensive biography of Arthur Henry Knighton-Hammond we depended for invaluable information. The exhibit would not have been possible without the dedication of Marjorie Gapp, who oversaw the exhibit design and installation and wrote the exhibit text. We also gratefully acknowledge the installation expertise of John Taylor and Gregory Tobias. We owe the catalog to the excellent hard work of Gina Frese who researched and wrote it, with assistance from her CHF colleagues Mary Ellen Bowden and David C. Brock, as well as to Will Brown, who photographed Knighton-Hammond's paintings. And we gratefully acknowledge the careful editing by Frances Coulborn Kohler, who contributed to the Industry in Art section as well, and the expertise of Shelley Wilks Geehr, who oversaw production.

Arnold Thackray
President, Chemical Heritage Foundation

v

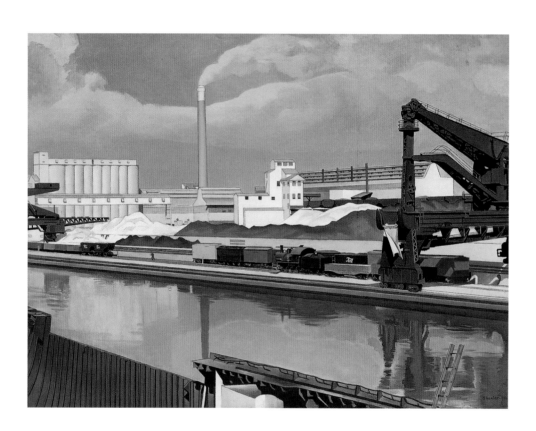

Charles Sheeler, **American Landscape** (1930). Oil on canvas, 24 x 31 in.
The Museum of Modern Art. Gift of Abby Aldrich Rockefeller.
Photograph © 2000 The Museum of Modern Art, New York.

Industry in Art

When Arthur Henry Knighton-Hammond arrived at The Dow Chemical Company in the spring of 1920, he was no stranger to industrial painting. During the late nineteenth and early twentieth centuries industrial themes captured the public imagination and even inspired movements in mainstream art. Knighton-Hammond, like other artists of his period, painted well-received images of an industrial landscape—itself without precedent in its scale and scope—that announced the dawn of a new age of mass production.

Predecessors

The treatment of industry in art actually began with the first stirrings of the Industrial Revolution. Artists who turned to the scenes around them for their subject matter would include the signs of this transformation, and they would paint the factory, the steel mill, the steam engine—using the same artistic vocabulary their peers might employ for country landscapes or domestic interiors.

In Britain, Joseph Wright (1734–1797), a native of Derby—one of the earliest industrializing cities—was perhaps the first professional visual artist to explore the industrial genre. Wright was one of the best painters of light in his day, and his works bear a resemblance to those of the Dutch followers of Caravaggio, juxtaposing intense, radiating light with the deepest shadows. Wright used this classical technique to capture the new vigor of modern science and industry.

Two of Wright's paintings capture separate elements of Knighton-Hammond's topic: chemistry and industry. *An Experiment on a Bird in the Air Pump* (1768) exhibits Wright's unique use of light to suggest a modern future, equating lucid illumination with advances in science

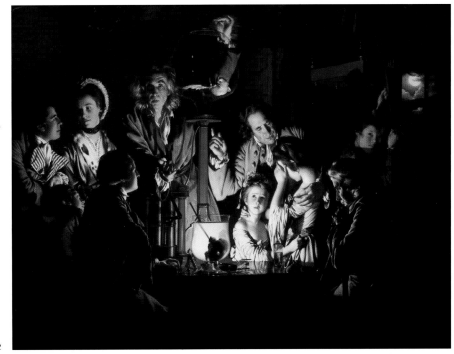

Joseph Wright of Derby, **An Experiment on a Bird in the Air Pump** (1768).
Oil on canvas, 72.1 x 96.1 in. © The National Gallery, London.

1

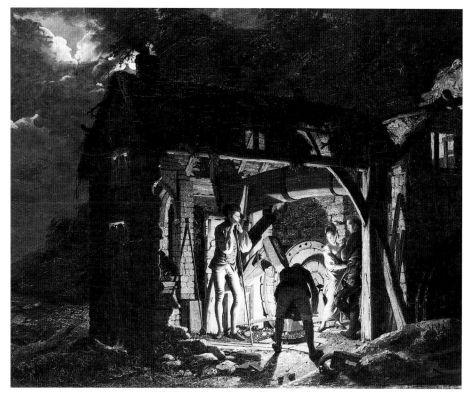

and technology. By his day the air pump had become a powerful symbol of the new experimental sciences—especially chemical inquiry. Robert Boyle had used the air pump a century earlier to develop pneumatic chemistry—and to advance knowledge of nature through new experiments rather than by philosophical debate in the Aristotelian tradition. In Wright's painting the pump is the source of illumination—the seat of science, the site where knowledge is created. The intense, glowing light from the experiment reveals the varied facial expressions, ranging from shock to wonder, of those watching it.

Wright makes a similar equation between light and technical power in an industrial scene: *The Iron Forge Viewed from Without* (1773), also painted in a Caravaggiesque style. The scale of the forge, though clearly outranking a typical "Vulcan's forge," is intimate compared with the factories of the late nineteenth and twentieth centuries, but the illumination from the glowing furnace shatters the surrounding darkness as though the power of industry could illuminate the way into the darkness of futures unknown.

Perhaps more celebrated are the reflections of Joseph M. W. Turner (1775–1851) on the new industrial landscape. These paintings by a precursor of the Impressionists rely more on atmospheric effects than on sharp contrasts of light, but the subjects are astonishingly similar to Wright's. Turner's watercolor *Interior of an Iron Foundry* (1797) recalls Wright's *Iron Forge*, though treatment—and the scale of the building—differ. In another watercolor, *Leeds* (1816), the smokestacks of an industrializing city create an atmospheric backdrop to a familiar genre scene on the road approaching it. Turner was undoubtedly influenced by the works of the Alsatian artist Philip James de

Joseph Wright of Derby, **The Iron Forge Viewed from Without** (1773).
Oil on canvas, 41.34 x 55.12 in. The State Hermitage Museum, St. Petersburg.

2

Loutherbourg, whom he knew and some of whose sketches of industrial sites he owned. Atmospheric effects contribute to the romanticism of de Loutherbourg's *Coalbrookedale by Night* of 1801, for example.

Turner's paintings, particularly those completed between 1832 and 1844, bear witness to the bustling energy of industrializing Britain and especially to the great changes the steam engine brought to society as it powered new trains, steamboats, and machinery. In *Rain, Steam and Speed—The Great Western Railway*, a steam-filled atmosphere allows only the rushing front engine of the train to be seen as it pushes forth from the shapeless vapors across a bridge into the light. The drama and sweep of the emergence of industrial might that Turner captured in his canvases earned him recognition as the premier painter of industrial subjects in Britain's early Victorian age.

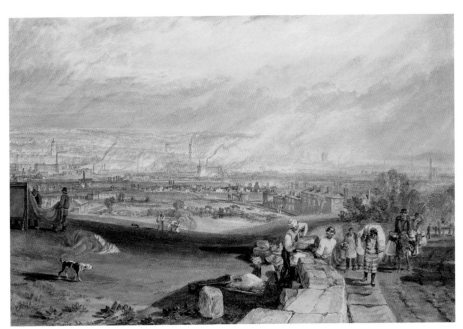

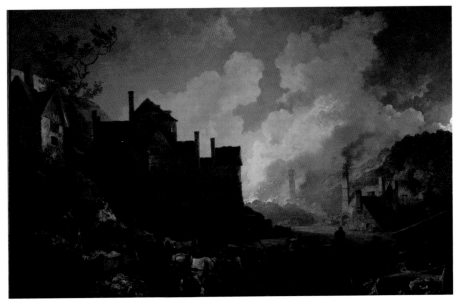

3

J. M. W. Turner, **Leeds** (1816). Watercolor on wove paper, 11.5 x 17 in. Yale Center for British Art, Paul Mellon Collection.

Philippe Jacques de Loutherbourg, **Coalbrookdale by Night** (1801). Oil, 26.77 x 42.1 in. Science Museum/Science and Society Picture Library, London.

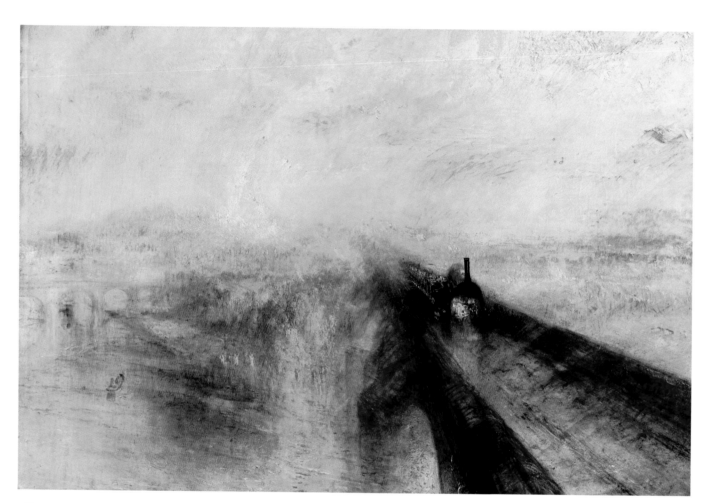

Contemporaries and Successors

By the turn of the century, painters of contemporary landscapes could scarcely avoid depicting industrial activity, and some—the French Impressionists among them—capitalized on its effects. Like Turner—and Knighton-Hammond—the Impressionists were attracted by the aesthetic qualities of steam and smoke. The steam generated by a railway engine dominates two famous paintings, Edouard Manet's *Railway* (1873) and Claude Monet's *Gare St. Lazare* (1877)—though the generating engine is not even visible in the Manet and is dwarfed by its own steam in the Monet. The Impressionists also painted forges and factories. Vincent van Gogh's factories at Asnières and Arles

J. M. W. Turner, **Rain, Steam, and Speed—The Great Western Railway** (1844).
Oil on canvas, 35.75 x 48 in. © The National Gallery, London.

from the 1880s usually appear as a peaceful smoky backdrop to rural activity, but the juxtaposition of water, smoke from the starch factory, and clouds in Claude Pissarro's *L'Usine, Saint-Ouen l'Aumône* (1873) foreshadows Knighton-Hammond's more dramatic treatments of the Dow plant.

Turn-of-the-century artists in the United States also were recognizing the effect of booming industry on society and incorporating this metamorphosis into their art. For them, however, the force and presence of industry is no mere backdrop. The American painter John F. Weir (1841–1926) captured the sense of the newly unleashed forces of industrial operations in *Forging the Shaft: A Welding Heat* (1877). This work, a large, powerful composition of the West Point Foundry, is one of the best-known paintings of early American industry. The work depicts a dozen steelworkers maneuvering a huge, blazingly hot cannon barrel from the forge; the light recalls Wright's *Iron Forge*, but the scale is even more dramatic.

Another American artist, Joseph Pennell (1857–1926), spent his career producing etchings and lithographs of architectural and industrial landscapes across the globe. Traveling throughout the United States, Pennell caught the aesthetics of industry in action. His images of steamboats, mills, bridges, and buildings bore witness to the creative power and

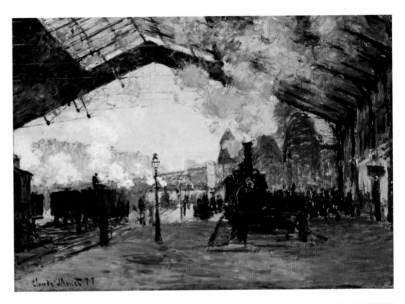

5

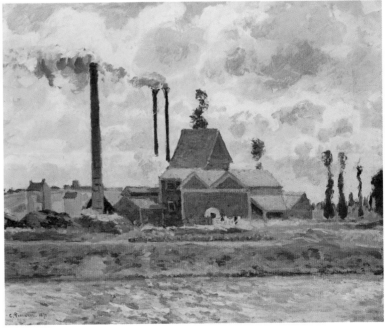

Claude Monet, **Arrival of the Normandy Train, Gare Saint-Lazare** (1877). Oil on canvas, 23.47 x 31.58 in. Mr. and Mrs. Martin A. Ryerson Collection, 1933.1158. Courtesy The Art Institute of Chicago. All rights reserved.

Camille Jacob Pissarro, **Factory near Pontoise** (1873). Oil on canvas, 18 x 21.5 in. The James Philip Gray Collection, Museum of Fine Arts, Springfield, Massachusetts.

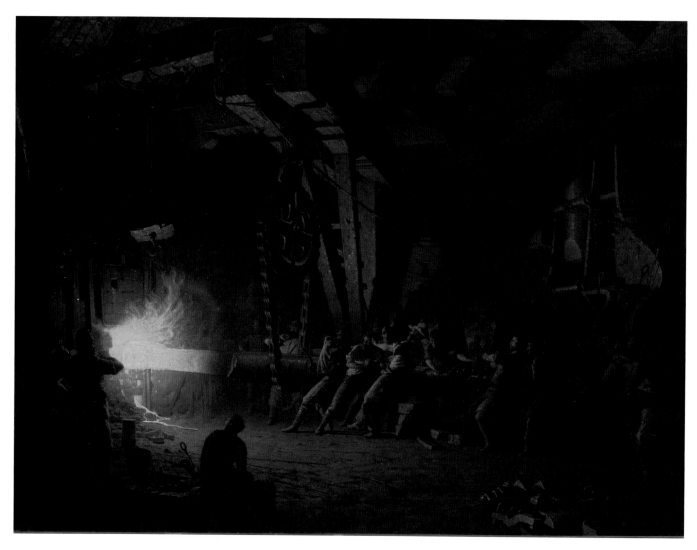

growing presence of industry in the New World. In the 1910s he traveled to Central America, and in 1912 he created lithographs of Gatun Lock in the Panama Canal. The Panama Canal presented U.S. industry with the major challenges of constructing the largest dam ever built and designing and building the most enormous canal locks ever imagined. Pennell captured the immense scale of this turn-of-the-century industrial achievement in such works as *Approach to Gatun Lock*.

John Ferguson Weir, **Forging the Shaft** (1874–77). Oil on canvas, 52.1 x 73.27 in.
The Metropolitan Museum of Art, Purchase, Lyman G. Bloomingdale Gift, 1901
(01.7.1). ©1983 The Metropolitan Museum of Art.

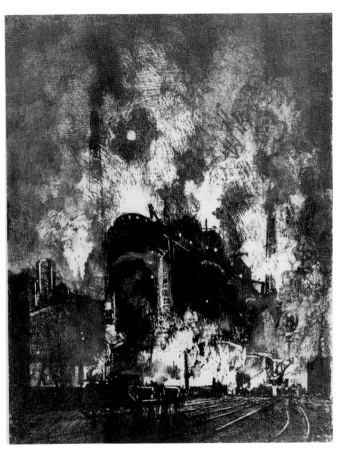

During World War I, Pennell's career took him to England, where he, like Knighton-Hammond, found that war production offered new challenges when it came to portraying a novel massive reorganization of industry. To convey the full force of that unleashed energy, Pennell collected his prints in a book, *Pictures of War Work in England*. Works like *Furnaces at Night* gain cumulative impact when seen together in that group.

By the early 1920s the factory, the machine, and major new forms of transportation were genuinely appreciated as aesthetic embodiments of modern experience. In Germany, America's past and future rival in two world wars, plants, machines, steamships, and railways appear repeatedly in work from the movement known as the Neue Sachlichkeit ("new realism"or "new objectivity"). In the United States a new generation of painters of industry known as the Precisionists worked to elevate industry to new artistic levels, flirting at times with the moral and

Joseph Pennell, **The Approach to Gatun Lock** (1912). Lithograph. Gift of Miss Elizabeth Achelis. © 2000 Board of Trustees, National Gallery of Art, Washington, D.C.

Joseph Pennell, **Furnaces at Night** (1916). Lithograph. Rosenwald Collection © 2000 Board of Trustees, National Gallery of Art, Washington, D.C.

8

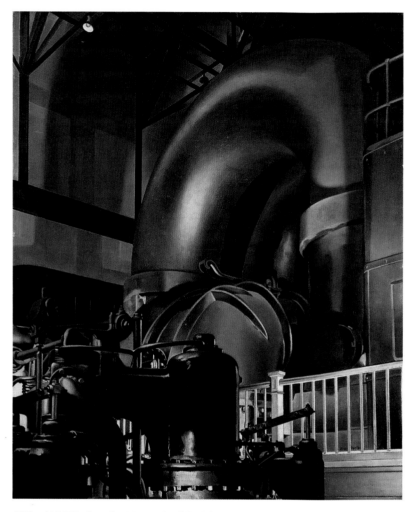

spiritual. Most notable among them were two Pennsylvanians who attended the Pennsylvania Academy of Fine Arts: Charles Sheeler (1883–1965), a Philadelphian, and Charles Demuth (1883–1935), from Lancaster.

Like many "modernists" of his day, Sheeler was drawn to the abstract works of Picasso, Braque, and Matisse and abandoned the academy's formal classical style. In 1919 he moved to New York, and in 1920 he collaborated with the artist Paul Strand on his first industrial vision: the short film *Manhatta*. The film was an artistic study of the new civic infrastructure of New York City—the Church Street elevated train line, for example. Sheeler then made his way as an industrial photographer throughout the 1920s and 1930s.

In Sheeler, industrial America aroused a near-religious admiration. He believed in its security and stability, and he once compared American factories to the great cathedrals of medieval Europe. A similar belief may inform *Die Schwimmerin von Köln* (1923), by the Neue Sachlichkeit artist Karl Hubbuch, in which a swimmer stands framed by the gigantic steel beams of a bridge, with the Cologne cathedral quoted, as it were, in the background. Other Americans shared Sheeler's vision, among them Henry Ford, who declared: "The man who builds a factory builds a temple. The man who works there, worships there." Fittingly, in 1927 Ford himself commissioned from Sheeler a six-week stint photographing the Ford company plant in River Rouge. The photographs capitalize on the intricate, calculated design of one new emblem of American industrial culture: the automobile factory.

Charles Sheeler, **Steam Turbine** (1938). Oil on canvas, 22 x 18 in.
Courtesy The Butler Institute of American Art, Youngstown, Ohio.

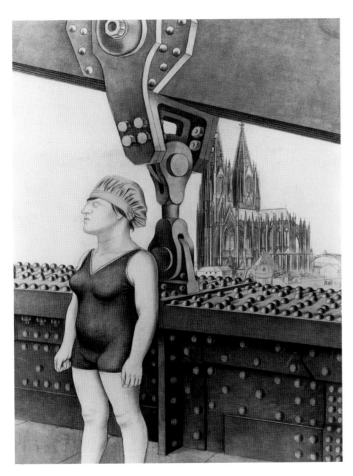

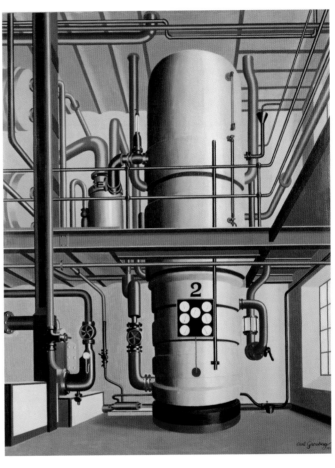

Other works reveal how similar the Precisionist and the Neue Sachlichkeit visions of industrial power could be. In 1938 *Fortune* magazine commissioned six paintings from Sheeler extolling American industry (the Power series). *Steam Turbine* (1939) shows the same monumental qualities that Carl Grossberg bestows on the pressure vessel in *Der gelbe Kessel* (1933). But it is Sheeler's famous industrial painting *American Landscape* (1930) that captured most strikingly the cool aestheticism of modern technology. A large plant silently stands along the horizon of a quiet sky, mirrored in a quiescent, impassive canal, its huge scale fixed by the pinpoint of a lone human figure walking along the railroad tracks. The angular, precise geometry of the work is disrupted only by a cloudy, amorphous plume issuing from a lone smokestack.

Karl Hubbuch, **Die Schwimmerin von Köln (The swimmer of Cologne)** (1923). Pencil and watercolor, 26.1 x 18.9 in. Städtische Kunsthalle Mannheim.

Carl Grossberg, **Der gelbe Kessel (The yellow boiler)** (1933). Oil on board, 35.43 x 27.55 in. Von der Heydt-Museum, Wuppertal.

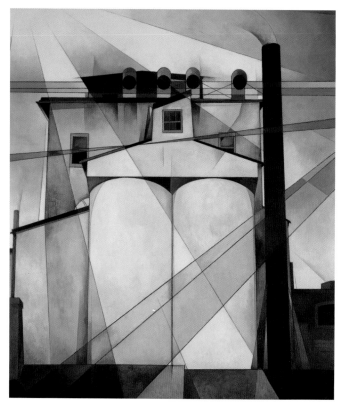

Demuth was similarly drawn to the new landscape of industrial America. A year in Paris (1907) and a two-year tour of Europe (1912–1914) exposed him to the creative ferment of Fauvism and Cubism, and he began experimenting with an analytical style of art in 1916, while visiting Bermuda. Demuth's vision of America is populated by a basic geometry of clean, mechanized industrial monuments. His well-known composition *My Egypt* (1927) makes the same equation between industrial and religious iconography as that expressed in Ford's words, Sheeler's work, and more blatantly in Hubbell's painting. The title of *My Egypt*, a controlled, planar oil painting of a large grain elevator, conveys the artist's spiritual conviction that industrial facilities dominate the American scene much as the sacred pyramids dominated the horizon of ancient Egypt.

The Corporate Collectors

The relationship between industry and art took a special turn in the early decades of the twentieth century, as the modern corporation arose and, with it, support from corporations for an entire range of cultural and artistic endeavor. Not only did firms and businesspeople begin to collect more and more fine and decorative art, but businesses started to commission and to sponsor art and culture on an unprecedented scale. Educational institutions, libraries, symphonies, opera companies, painters, sculptors, and writers all received the benefits of corporate support, commissions, and philanthropy in different forms. Corporations used this direct support of art and culture to enhance their standing in their communities and to enrich the lives of their employees and their families.

In the 1910s and 1920s many corporations had not divided their commissions categorically into those strictly for civic improvement and those for advertising ends. In this period such firms sought out artists who could produce expressive representations that could be used equally for public enrichment and for public relations. The chemical industry was particularly active in these early experiments in corporate sponsorship and patronage of art in the twentieth century.

Charles Demuth, **My Egypt** (1927). Oil on composition board, 35.75 x 30 in.
Collection of Whitney Museum of American Art.
Purchase, with funds from Gertrude Vanderbilt Whitney, 31.172.
Photograph © 2000, Whitney Museum of American Art.

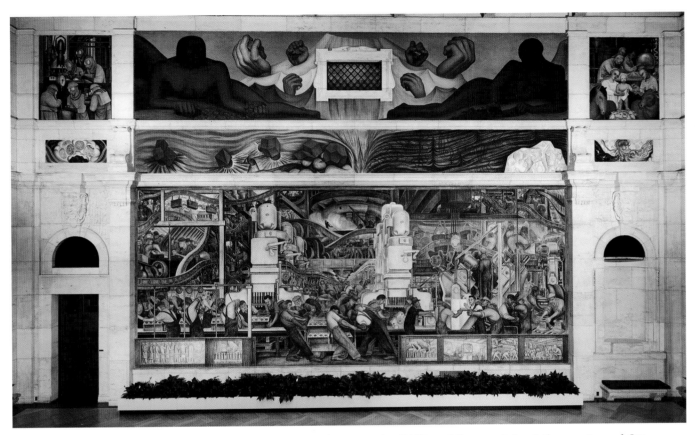

In Europe, for example, the German industrial companies BASF and Bayer retained the services of Otto Bollhagen (1861–1924) in the 1910s to paint industrial landscapes of their facilities for advertisement, public promotions, and decoration of their facilities. In 1910 Carl Duisberg—a Bayer chemist and member of the board of directors—brought Bollhagen to Bayer's Leverkusen plant. By 1911 Bayer had produced a large engraved collage overlapping five of Bollhagen's paintings of various Bayer plants across the globe: Leverkusen, Elberfeld, Flers (northern France), Moscow, and Albany (New York). Bayer used this form of Bollhagen's work for a successful advertising venture.

Dow's commission for Knighton-Hammond was itself inspired by an example of corporate sponsorship and patronage of art: an exhibit of paintings by National Aniline and Chemical at the 1919 National Exposition of Chemical Industries. And Herbert Dow's choice of an artist with the skills and reputation of Knighton-Hammond

Diego Rivera, **Detroit Industry, North Wall** (1933). Fresco; lower panel,
17.67 x 45 ft. Gift of Edsel B. Ford Fund. © Detroit Institute of Arts.

repaid the company well, eclipsing the rival paintings and generating substantial prestige for Dow Chemical. Other corporations were not slow to follow Dow's lead, commissioning works for display at international exhibitions and trade shows and other prominent locales that promoted the achievements of individual firms and of American industry as a whole. One commission displays the same overlap as Dow's between corporate self-promotion and corporate support of the arts—and a similar concern with the quality of the artist. In 1933, using a gift from the Edsel B. Ford Fund, the Detroit Institute of the Arts contracted with the world-famous Diego Rivera (1886–1957) to produce a mural: a huge, multipaneled tableau of the Ford Company's River Rouge Plant.

As the media exploded in what has been called the dawn of America's "Advertising Age," commissioned art was increasingly used as a vehicle for promoting a firm and its products to wider audiences. Throughout the 1940s Standard Oil of New Jersey hired artists to create in visual media a grand narrative about the great technological achievements of the oil industry. Like Dow, Standard of New Jersey used these artistic productions as agents of positive advertising, often reproducing them on the cover of their magazine, *The Lamp*. Again Ford hired numerous artists to photograph and portray its facilities decade after decade—Charles Sheeler, as we have seen, among them. Ford used the works these artists produced for various publications and advertisements, and they appeared widely in traveling exhibitions.

Beyond the aesthetic interest of the Knighton-Hammond commission (Augustus John called the artist "the greatest painter in water-colours of our time") and its reportorial value as a record of an industry, the commission is significant as a classic example of how fertile corporate support of art can be. The widespread and generous support of art and culture by corporations in our present age owes much to the daring and the vision of figures like Dow and Knighton-Hammond. ●

Knighton-Hammond:
The Artist and Dow

Early Life and Career

The youngest of William and Mary Hammond's six children, Arthur Henry Hammond (later, Knighton-Hammond) was born on 18 September 1875, in Arnold, Nottingham, England.* Arthur Hammond grew up in a traditional Victorian family of shopkeepers; his father owned and operated a combination furniture and hardware shop. Early in his youth he was distinguished by a remarkable talent and great enthusiasm for drawing. He attended the National School in Arnold until the age of six and then went to the nearby British Board School until the age of eleven. Outside of school young Arthur worked in his elder brother's grocery store—a job he loathed. Despite these early demands he could often be found stealing away into the countryside, sketchbook in hand.

When Arthur was twelve, his father arranged an apprenticeship for him with a watchmaker named Sam Allen. The work was tedious and the hours were long, but the boy persevered to please his aged and ailing father. Throughout this apprenticeship he attended evening classes at the Nottingham School of Art, where his talents were recognized immediately. He won second prize in geometry as well as in perspective drawing—no small feat for a beginning student attending classes only a few nights per week.

Arthur Hammond took his first formal exams in model and free-hand drawing at the Nottingham School of Art at the age of sixteen and earned the highest grade possible in both. Kindly realizing that his apprentice's talent and passion lay elsewhere, Sam Allen released him early from his watch repair indenture. Arthur continued to contribute to his family's income by repairing watches two days per week on his own. The rest of his time he devoted to his artistic studies, continually winning high marks in all his classes. In 1896 he took his four-hour final exams alongside both the advanced students and the instructors themselves. When the results were posted, he learned that he had received the highest rating, surpassing even his instructors. There was no doubt that a career in art awaited Arthur Knighton-Hammond.

In November 1900 Knighton-Hammond moved to London to pursue his career in a new, cosmopolitan environment at the center of the British art world. He left home with a single trunk of clothes and belongings and a mere ten pounds and three guineas to his name. After arriving in London, he and a fellow budding artist, Herbert Hitchin, rented two empty rooms for ten shillings per week. These cramped quarters became both home and studio for Knighton-Hammond. Yet although he was productive artistically, he did not sell many works, and living from hand to mouth was difficult. He returned home to celebrate Christmas with his family, dejected. However, the pleasant holidays bolstered his outlook, and he returned to London determined to make his way as an artist. He secured a commission and began a series of four watercolors depicting hunting scenes—a popular theme at the time—using his new funds for art classes at both the Westminster School of Art and the Chelsea School of Art.

** Knighton-Hammond adopted his mother's maiden name, without a hyphen, around 1912; he then officially added it to his surname in 1933. This catalog uses the hyphenated version throughout.*

While Knighton-Hammond's skill and talent were evident, he continued to struggle financially. At one time he even pondered abandoning his artistic career for employment that offered a more certain income. Fate intervened, however. After reading about the popular Oaks horse races, he decided to paint a watercolor of the finish of an Oaks race, hoping to sell it to Fores, an art publishing company in Piccadilly. Once he completed the racing scene, he packed it and a few earlier compositions and made the journey to Piccadilly. There the artist sold not only the Oaks race painting to Fores, but also the remaining paintings to another local art dealer.

With renewed faith in his abilities Knighton-Hammond fervently expanded his artistic endeavors. He began designing and painting scenes for postcards. A widespread fancy for these postcards soon secured employment from several publishers. This work, coupled with tuition payments from some art students of his own, finally provided the steady income he had sought, along with growing recognition. Still, Knighton-Hammond was restless; his real desire was to paint landscapes.

With a career under way Knighton-Hammond married Winifred Reeves on 29 May 1902. The couple moved soon after to Marlow-on-Thames, a scenic riverside town popular for summer boating, where Knighton-Hammond joined a small community of artists. He continued to paint hunting scenes, but he extended his range with portraits of his wife and the landscape painting to which he had always aspired. By the time of his second daughter's birth in 1905 Knighton-Hammond had a large portfolio, which he regularly exhibited in his home. The need to follow commissions and other financial considerations led him and his family to relocate many times. Each time he seemed to draw more and more creative energy from his surroundings. Between 1905 and 1914 he painted several brilliant landscapes.

Industrial Landscapes

Knighton-Hammond began his long and productive engagement with industrial subjects during World War I. In 1917 he was classified "C-3," the lowest rating possible, by the War Medical Board. Active service at the front was out of the question; he was thus detailed to a Ministry of Munitions drawing unit, where he produced engineering drawings of diverse structures and components. His talent and skill earned him the title of chief draftsman. After a few months Knighton-Hammond met Lord Moulton, director general of the Explosives Supply Department in the Ministry of Munitions, a department created to gear up the British dyestuffs industry to supply the raw material for high explosives. Moulton was thoroughly impressed with Knighton-Hammond and offered him a job drawing the newly developed coke ovens, munitions factories, acid-making facilities, and granaries that were being constructed for the war effort. These novel plants reflected a period of significant industrial change and advance in Britain, especially for the chemical process industries, and Lord Moulton wanted a pictorial record of this evolution and development of new technologies. Knighton-Hammond accepted the commission.

Soon after accepting, Knighton-Hammond met with Joseph Turner, the joint managing director of British Dyes Limited, who took over supervising the artist's work from Moulton in 1918. Turner assigned Knighton-Hammond to British Dyes' new plant, the Dalton Works in Huddersfield. The artist made numerous landscape renderings of the plant's facilities, many in pencil, which added an "in the making," dynamic edge to the scenes. (Knighton-Hammond later transformed some of these pencil drawings of Dalton into etchings, such as *The Gas Producer Plant* and *View of Dalton Works from Near the Reservoir*.)

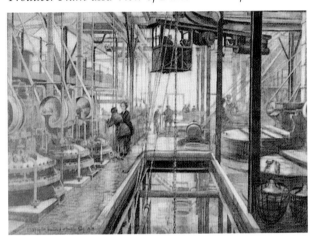

Knighton-Hammond produced numerous drawings of the Dalton Works, including *Oleum Plant, Benzidine Shed*, and *Nitric Acid Shed*. Nitric acid was a vital chemical for the war effort, a crucial substance used in the production of both badly needed fertilizers and high explosives. Benzidine was essential for the manufacture of the azo dyes, dyes that were in acute demand since they required no mordant in order to be fixed to cotton textiles. Oleum, too, was a key ingredient in dyestuff production. Known also as "fuming sulfuric acid," oleum (a solution of sodium trioxide in 100-percent sulfuric acid) was used in production processes for many organic chemicals. Knighton-Hammond's scenes of the Dalton Works were thus views of chemical processes and technologies central not only to the war effort but also to the expanding British chemical industry.

Later in 1918 Knighton-Hammond executed a watercolor landscape of a nearby British Dyes plant at Turnbridge, afterward returning to the Dalton plant to paint a similar scene (*View of Dalton Works*). Throughout 1919 he continued to work at both the Turnbridge and the Dalton plants, rendering scene upon scene in oil and watercolor. Also in that year British Dyes exhibited Knighton-Hammond's compositions at Manchester Technical College, where his work garnered the interest and praise of many. Croyden Meredith Whittaker, chief colorist for British Dyes, used twenty-five of these pieces to illustrate technical and industrial advances in the book *Some Modern Tendencies in Dyeing, Coupled with a Few Notes on Colour Manufacture* (1919).

By this time Knighton-Hammond was ready to seek new subjects and patrons for his artistic pursuits. In the course of his work for the British dyestuff industry he became quite impressed with the tremendous advances of American industry during the war years, especially the American chemical process industries. The artist now began looking across the Atlantic to the new center of industrial progress—and the many opportunities for commissions that accompanied it.

Benzidine Shed, Dalton Works (1918). Pencil, 14.5 x 21 in.
Courtesy Zeneca Specialties.

15

To the States

Knighton-Hammond wrote to The Dow Chemical Company on 8 May 1919, offering his services as an artist. The reasons behind his choice of Dow remain unclear. He may well have heard of the firm while working for what was now the British Dyestuffs Corporation, a company formed during the consolidation of British chemical industries in the immediate postwar period.

Before the war German chemical manufacturers dominated the world trade in synthetic dyes. With the outbreak of hostilities, countries like the United Kingdom and the United States faced an immediate and acute shortage of these dyes, most notably synthetic indigo, as trade with Germany was severed. In the case of indigo Britain met the challenge by seizing the British plant of a German manufacturer and turning its operation over to a British firm, Levinstein Limited. In the United States, Dow Chemical exhibited its technological ingenuity and entrepreneurial daring by rapidly starting its own synthetic indigo research program. By 1 January 1917 Dow had succeeded in producing—and selling—the first American synthetic indigo dye.

In 1919, the year Knighton-Hammond wrote Dow, Knighton-Hammond's then-current employer, British Dyes, combined with Levinstein to form the British Dyestuffs Corporation. Knighton-Hammond could have scarcely avoided hearing of Dow, the American industrial powerhouse that was his employers' new competitor for the synthetic indigo trade. Knighton-Hammond was evidently so impressed by Dow's reputation that he actively sought to make the company his new patron. His 1919 letter to Dow reads:

> My purpose in writing to you is as follows: As a professional artist I have for some years been engaged (especially so during the War) in making drawings and paintings of picturesque and effective scenes in engineering and chemical works, collieries, and granaries. . . . These pictures include all kinds of designs (painted on the spot from nature) useful for propaganda purposes and as a pictorial record. . . . [I] am writing to you to ask if you care to commission me to undertake a series of paintings on your works.

Knighton-Hammond could have hardly known that his letter would find such a receptive reader. Herbert Dow and his wife, Grace, both held a deep fondness for art. Avid personal collectors of paintings and enthusiasts of culture, the couple often took their children on trips to New York City to scour galleries, attend the theater, and stroll through museums. As Herbert and Grace's daughter, Dorothy Dow Arbury, recalled:

> I don't think they ever went on a trip in their lives that they didn't go someplace and look at paintings. She [Grace Dow] used to take us to the Metropolitan Museum practically every time we went to New York. . . . [For their personal collections, Grace] studied the artist, and then she went looking for their pictures.

When Knighton-Hammond's offer letter reached Herbert Dow's desk, Dow had already been contemplating harnessing his personal enthusiasm for painting to the promotion of his company. Affected by the economic

16

depression that occurred after the war, Dow Chemical had entered a period of relative stagnation. After attending the National Exposition of Chemical Industries in 1919, where he saw a rival company's success with paintings of their industry, Dow believed that artistic renderings of his own plant would enhance the company's public profile and thereby its business. An astute businessman who was selflessly devoted to his company, he first thought of capturing the plant in a series of murals, as he wrote when he replied personally to Knighton-Hammond's letter:

> We have thought a number of times that if we could have some mural decorations in one or two of our rooms representing scenes that are typical of our plant, we would like to have them. . . . At the National Exposition of Chemical Industries, the writer [Dow] noted a number of fine paintings shown by the National Aniline & Chemical Company that were very much a credit to their exhibit. . . . [We] would be pleased to have you make us a proposition so that we could get some idea of the expense of making several mural decorations.

Dow learned more about Knighton-Hammond's experience and talent through subsequent correspondence, and he decided to agree to the artist's proposal for a major commission. On 24 December 1919 he formally accepted Knighton-Hammond's offer to create paintings of various areas within the Dow plant for a princely stipend of five thousand dollars, payable over six months. Mindful of Midland's harsh winters, Dow warned Knighton-Hammond that "the landscape is not what it is in more congenial seasons" and advised him to wait until the spring of 1920 to begin his journey. Knighton-Hammond boarded the steamer *Mauritania* to the United States on 12 April 1920, reaching Midland on 27 April. He had sent his painting and drawing supplies in advance and began sketching the day after his arrival there.

The Commission . . .

Before Knighton-Hammond's arrival Herbert Dow had suggested some locations in the plant as possible scenes for the commissioned paintings, going so far as to furnish the artist with several photographs of plant sites. Accustomed to industrial surroundings, Knighton-Hammond seemed to have an intuitive grasp of the Dow plant and of those areas that would provide the best subject matter for his paintings. One of his first works at Dow was an oil painting titled *47 Building Machine Shop* (plate 1), followed shortly after by two paintings of the caustic pot houses (plates 3 and 4) and one of the indigo plant (plate 5). Attracted to the interior activities and processes of the plants, he painted these initial locales indoors and from an elevated vantage point, providing an aerial view of the plant's inner workings.

As spring progressed and the weather improved, Knighton-Hammond moved his painting operations outdoors. In May 1920 he worked on several paintings of plant exteriors, including watercolors of the potash towers (plate 8) and the Epsom salt plant (plate 9). He also completed two lush and beautifully rendered oil paintings

of the Dows' apple orchard at this time (plates 6 and 7). Beyond his commissioned work for Dow, Knighton-Hammond painted many pieces in his free time. While in Midland, he exhibited twice at the Community Center, where he sold several of the extracurricular compositions. By the end of September 1920 Knighton-Hammond had finished about twenty-five paintings for the Dow commission. These were transported to New York City for The Dow Chemical Company's exhibit at the National Exposition of Chemical Industries on 7 October, in the Grand Central Palace. The exposition, held every year, drew as many as sixty thousand visitors. The response to Knighton-Hammond's work was very favorable, and his paintings proved an excellent medium for promoting Dow Chemical in the public eye. Moreover, Herbert Dow was personally hailed for recognizing the aesthetic qualities of his plant and securing the talent of Knighton-Hammond to capture them. Writing about the Knighton-Hammond commission at Dow in the *Color Trade Journal* in 1921, J. Merritt Matthews summed it up: "Mr. Dow can well take the credit of playing the genial host and of having the vision of the soul that lies behind the heart and brain of industry."

By the end of his six-month commission Knighton-Hammond had created nearly forty pieces for Dow. After the 1920 National Exposition, Dow presented two pieces as gifts—giving *The Power House* to The Chemists' Club and *The Indigo Shed* to the American Dyes Institute. Today twenty of these compositions remain in the possession of the Dow Foundation.

...and a Friendship

During Knighton-Hammond's stay in Midland his professional relationship with Herbert Dow blossomed into a social relationship as well. Dow and his wife frequently invited Knighton-Hammond to dinner, and Dow introduced Knighton-Hammond to employees at the plant as well as to his circle of personal friends. When the Chicago meat-processing firm Armour and Company considered securing Knighton-Hammond's artistic services, Dow provided them with a reference certifying the quality of Knighton-Hammond's creative abilities. Dow's sons, Alden and Willard, also developed close relations with the visiting artist. Fascinated by Knighton-Hammond's work, Alden watched him paint in Dow's apple orchard and give his father impromptu watercolor lessons. Willard, for his part, helped teach the artist how to drive a car. Even after Knighton-Hammond left the United States, in December 1920, his friendship with Herbert Dow endured. He and Dow corresponded across the miles. From families to finances, literature to livelihood, the two friends conversed about everything for several years.

Time and distance eventually eroded their camaraderie. After a six-year hiatus in their communication Knighton-Hammond decided in February 1933 to rekindle his friendly correspondence with Herbert Dow. When the reply came from Willard Dow, Herbert Dow's son, the artist was concerned. When he wrote Willard for more information, Knighton-Hammond was heavyhearted to hear that his friend Herbert Dow had died in October 1930. ●

The Dow Foundation's Collected Works of Knighton-Hammond: Paintings and Processes

During his six-month commission at The Dow Chemical Company, Knighton-Hammond painted extensively. His journal—kept from April through December 1920—reveals that he created over forty pieces. Several works were either given as gifts or returned home with the artist as part of his personal collection. Today about twenty compositions remain with the Dow Foundation, nineteen of which are presented in the Chemical Heritage Foundation exhibit. Of these, fifteen are oils, two are pencil drawings, and two are watercolors. The paintings are much more than scenes of The Dow Chemical Company; they are images of a central presence in a small midwestern town and the heritage of its inhabitants.

Known in painting circles as a first-class watercolorist, Knighton-Hammond transferred his dexterity to oils while painting at Dow Chemical. He revealed the reason behind this choice of medium even before his arrival in a letter to Dow on 16 February 1920. "The strong, impressive scenes on the works are more suitable, as a rule, in oils." To capture that strength, Knighton-Hammond broke out his brushes and oil paints on his arrival at Dow and headed for the machine shop and caustic pot house.

Of the works that remain in the Dow Foundation's collection, five canvases represent interior views of The Dow Chemical Company's plants. According to the artist's daily journal, he began to paint *47 Building Machine Shop* (plate 1) on 30 April, shortly after his arrival in Midland. This relatively small interior view overlooks busy shop workers on the floor below. Knighton-Hammond captured even the finest detail, down to the workers' colorful coats neatly lined up against the left wall.

With the same deftness Knighton-Hammond painted *Partial View of Caustic Plant Interior* (plate 2) and *Caustic Pot House Caustic Soda Production, Midland, Michigan, I* (plate 3), which he later copied in a nearly identical version titled *Caustic Pot House Caustic Soda Production, Midland, Michigan, III* (plate 4). Caustic soda was a positive remnant of the chlorine process. Electrolysis of the salt from Dow's vast brine deposits produced chlorine. During this process extra sodium reacted with the water to produce caustic soda as a by-product. Caustic soda proved to be a lucrative commodity for Dow, and it was used in many of Dow's chemical process applications. It was sold for use in the manufacture of soap, lye, rayon, and wood pulp for paper, as well as for the refining of petroleum, mineral and vegetable oils, and fats. Caustic soda was also used in the bleaching, dyeing, and printing of fabrics, a particularly significant use for Dow's developing dye business.

Dow began to produce indigo dye during World War I. When England successfully blockaded Germany, the world's primary supplier of dyes at the time, American chemical companies quickly rose to the challenge and answered the world's demand. Most intense was the demand for indigo dyes, and Dow Chemical gave the textile industry the first American-made indigo dye in 1916. By the time Knighton-Hammond arrived at Dow, American consumption of indigo had increased, and Dow increased its production of indigo to match. Chemically combining bromine—Dow's primary commodity—with indigo resulted in different hues of blue dye, varying from

red-blue to green-blue. These blues, known as Midland Vat Blues, were stronger in color and in fastness than common indigo.

On several occasions Knighton-Hammond noted in his journal his time spent painting in the "indigo shed." Producing indigo required using large pots for a sodium reaction with an indigo intermediate; the interior of the indigo shed thus bore a very close resemblance to that of the caustic pot house. One work in particular appeared in The Dow Chemical Company's 1928 catalog of chemicals, with the caption *Interior View—Indigo Plant*; however, the formal title of this painting is *Caustic Pot House, Caustic Soda Production, Midland, Michigan, II* (plate 5). This composition features another view of the plant operations from an elevated perspective. Seeking shelter from the vagaries of Midland's climate and taking advantage of the plant's structural scaffoldings, Knighton-Hammond took to sitting up among the rafters. He executed the work in oil with rich blue and purple overtones, possibly to capture the essence of the indigo dyes that the plant produced.

By the late spring of 1920 Knighton-Hammond was able to paint outdoors more often. In May he visited Herbert Dow's apple orchard and painted the two exquisite oils: *Spraying in H. H. Dow's Apple Orchard with Brine Well in Background* (plate 6) and *H. H. Dow's Apple Orchard, Midland, Michigan* (plate 7). Both canvases are bright and pastoral with quick, impressionistic brush strokes forming the fresh green and white-blossomed landscape. Close examination of the first work reveals that the roof appearing in the distant background is that of the Dow family homestead. These two apple-orchard paintings have been among the favorites of the Dow family for generations.

Inspired by the lovely spring weather, Knighton-Hammond switched mediums and venues. Outdoors, he worked on several watercolors around the Dow plant, including the two currently in the Dow Foundation's possession. Knighton-Hammond executed his watercolors delicately and spontaneously, a technique well suited to working "from nature" in the open air. Knighton-Hammond completed the most precisely dated piece in the collection, *Part of Cal-Mag Production, Midland, Michigan* (plate 8) on 10 May 1920, using a very free, flowing brush stroke. The dreamlike clouds and curling smoke from the stacks add a mystical and romantic ambience to the industrial setting of the four sturdy, upright storage tanks used in Dow's calcium-magnesium, or "cal-mag," brine process. This procedure comprised several steps. Once bromine had been extracted from brine, the remaining product could be used to recover several other useful chemicals, including sodium chloride, potassium chloride (potash), strontium chloride, magnesium chloride, and calcium chloride. Producing the last compound required precipitating the magnesium hydroxide to separate the magnesium from calcium chloride. Calcium chloride was then recovered using an evaporation process. The tanks in this painting may represent storage units for the various products that resulted during the calcium chloride recovery process.

20

At this time Knighton-Hammond completed the watercolor now titled *Epsom Salt Plant, Midland, Michigan* (plate 9). Again he captures the lively environment of the plant with just a few free and fluent, but purposeful, brush strokes. A photograph of Epsom salt taken for Dow's 1928 chemical catalog shows the salt stored in wooden barrels and burlap bags, much like the barrels or sack-shaped objects that appear just left of center in *Epsom Salt Plant*. In his journal, however, Knighton-Hammond recorded this painting as a watercolor of Dow's lead arsenate shed—not of the Epsom salt plant. Lead arsenate was a well-known and highly successful insecticide used in fruit orchards at that time, and Dow was a leader in its manufacture. The disparity between Knighton-Hammond's journal and the watercolor's title probably occurred because the lead arsenate shed adjoined the Epsom salt plant. In the 1920s Dow produced two varieties of Epsom salt: medicinal and technical. Medicinal Epsom salt, typically mixed into soaking baths, was used in veterinary medicine as well as in general medical treatment for skin ailments, muscle strain, and soreness. Technical Epsom salt had several uses, including tanning leathers and increasing water resistance in plastic magnesia cements.

As his work for Dow progressed, Knighton-Hammond sought new locations from which to paint the plant. Dow's facilities are located on the banks of the Tittabawassee River, and Knighton-Hammond recognized the artistic value of the site. He began several landscapes incorporating views of both plant and river. Striving to commingle the aesthetic power of industry with that of nature, Knighton-Hammond echoed the colors of the natural landscape in his rendering of the massive plant structures rising up from it. *Looking Down the Tittabawassee River at the Dow Chemical Plant, Midland, Michigan* (plate 10) and its study drawing, *The Dow Chemical Works by the Side of the River Tittabawassee at Midland, Michigan* (plate 11), take advantage of a vista opened by a curve in the river. The painting, executed in oil, features the marriage of two forces, nature and industry—the fluid strength of the river reflecting the stalwart efficiency of the plant. The other oil compositions incorporating the Tittabawassee River have comparable themes. For example, *Caustic Pot House Stacks, "A" Power Stack, "A" Pump Station, and "A" Evaporator Building* (plate 12) depicts the facilities' reliance on the river for their primary water intake. Water and factory are melded in the undulant reflection of the sun-drenched, salmon-colored edifices. *View from the River Showing "A" Power Pump Station and Discharge Flume* (plate 13) and *"G" Power House and Caustic Evaporator, Midland, Michigan* (plate 14) are also reflective visions that tie the river and nature to the edgy workings, puffing smokestacks, and humming industry of the bustling Dow plant.

The "A" powerhouse was the largest of the power sources at the Dow plant. Sporting the large white letters "DOW" near the top of its stack, the powerhouse could easily be spotted in aerial photographs of The Dow Chemical Company. The "A" powerhouse appears in other Knighton-Hammond paintings as well. The bright and richly colored *Brine Well with "A" Power House in Background, Midland, Michigan* (plate 15) is a fine example.

21

Although the "A" powerhouse bears the Dow name, the brine well remains the most significant icon for The Dow Chemical Company. Herbert Dow first moved his company to Midland in 1890 precisely so that he could extract bromine from Midland's brine-rich underground deposits. The brine well was at first used only for extracting the brine from the earth in order to get bromine, but eventually it was used in retrieving other commercially valuable chemicals, such as calcium, chlorine, magnesium, and sodium.

Toward the close of his commission at Dow, Knighton-Hammond painted *The Dow Chemical Company Main Office Building, Midland, Michigan* (plate 16). The drawing *The Dow Chemical Company's Works at Midland, Michigan, USA* (plate 17) may be a study for this work. Again, powerhouse "A" is visible in the background of both compositions along with Dow's other busy smokestacks. In the oil painting you may also see Herbert Dow's car parked underneath the office building's carport on the far left. This physical sign of Dow's presence reminds us of how immersed he was in his company.

The last two paintings in the Dow commission are *The "Nail" Process Plant, Midland, Michigan* (plate 18) and *Lime House and Mill* (plate 19). These two works, which depict adjacent subjects, form a panoramic view when placed side by side. Whether Knighton-Hammond began painting these canvases at the same time is unknown. *The "Nail" Process Plant* depicts, in fact, calcium chloride and magnesium chloride tanks. The term *nail* had nothing to do with the end product of this plant but was rather the Dow vernacular for one of the firm's processes for recovering valuable substances from debrominated brine feedstocks, in this case a hydrated double salt of calcium and magnesium chlorides known as tachydrate. When the crystallized tachydrate was redissolved and treated with so-called slaked lime (calcium hydroxide slurry), both magnesium hydroxide and calcium chloride were recovered. Calcium chloride was a product in itself, and the magnesium hydroxide was subsequently used to produce Epsom salt and to yield magnesium metal—all key Dow products. Dow workers originally referred to the plant as the "tack" process plant after the tachydrate it produced. As demand for the end products increased, so did Dow's production capacity and, hence, the scale of the tack plant. The workers felt that the growing plant deserved a new nickname that reflected its newfound size—thus the evolution from "tack" to a larger item in the same genre, the "nail."

The neighboring lime house and mill served the operations of the "nail" process plant. There the slaked lime mentioned above was produced and stored. Crushed limestone was converted into lime (calcium oxide), which was in turn mixed or "slaked" with water in tubs to form slaked lime. Producing magnesium metal from Midland's brine source, in which the "nail" process plant and the limehouse played their parts, became an increasingly significant process for Dow. After Herbert Dow's death in 1930 The Dow Chemical Company's magnesium production advanced at a remarkable pace. Knighton-Hammond, intentionally or not, captured on these two canvases the early developmental stages of one of Dow's most profitable process industries.

22

As Dow expanded throughout the United States over the years, Knighton-Hammond's paintings found their way into Dow offices across the country. The paintings, with their themes of aesthetic industry and nature, enjoyed wide audiences wherever they were placed—catalogs, exhibitions, and chemical expositions alike. Through the dedicated efforts of the Dow Foundation, the collection presented here was reassembled, and where necessary, paintings were cleaned and restored to their original magnificence. Before arriving at the Chemical Heritage Foundation, many of Knighton-Hammond's canvases adorned the walls of the Dow Foundation House. The collection stands today as an enduring representation of Dow's industrial presence and significance, a meaningful remembrance of Midland history, and a trove of fascinating visual stories about a company and the man who constructed and nurtured it. ●

| **47 Building Machine Shop** (1920). Oil on canvas, 13.75 x 20.5 in.

26

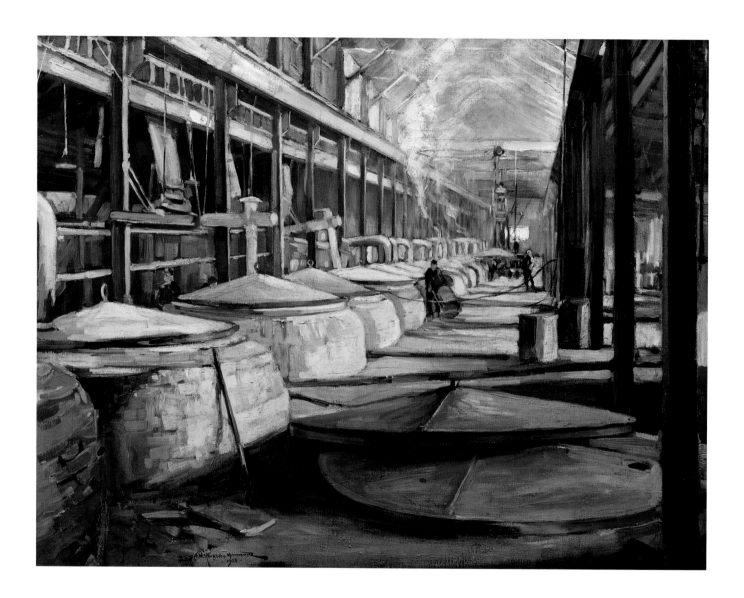

2　**Partial View of Caustic Plant Interior** (1920). Oil on canvas, 27.25 x 35.25 in.

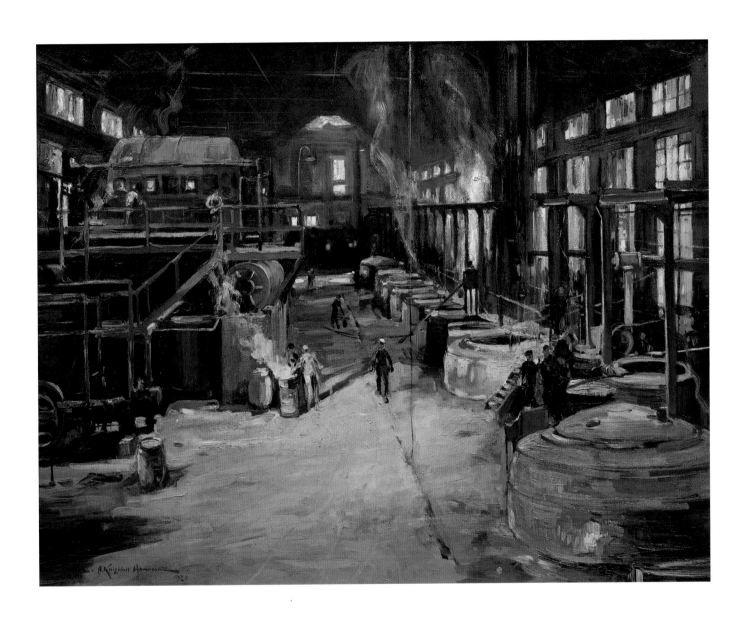

3 **Caustic Pot House Caustic Soda Production, Midland, Michigan, I** (1920).
Oil on canvas, 27.5 x 35.5 in.

28

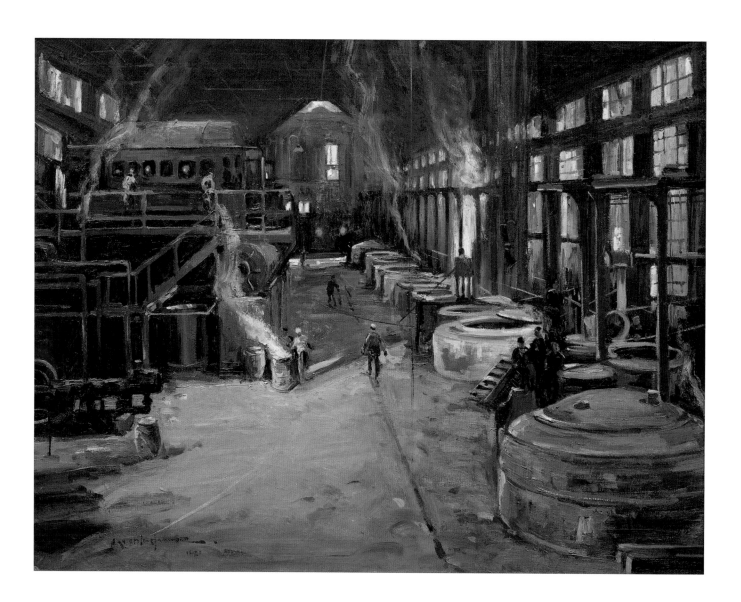

4 **Caustic Pot House Caustic Soda Production, Midland, Michigan, III** (1920).
Oil on canvas, 27.25 x 35.75 in.

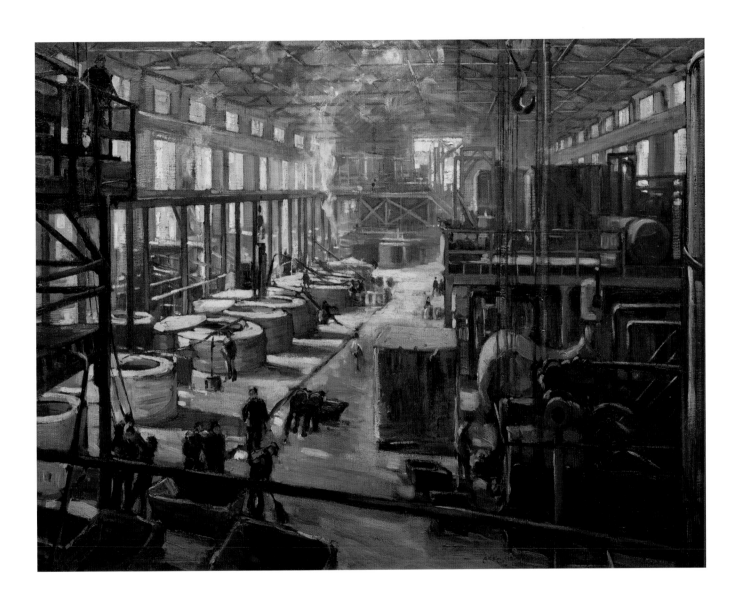

5 **Caustic Pot House Caustic Soda Production, Midland, Michigan, II** (1920).
 Oil on canvas, 27.75 x 35.25 in. Referred to in 1928 Dow catalog as *Indigo Plant*.

30

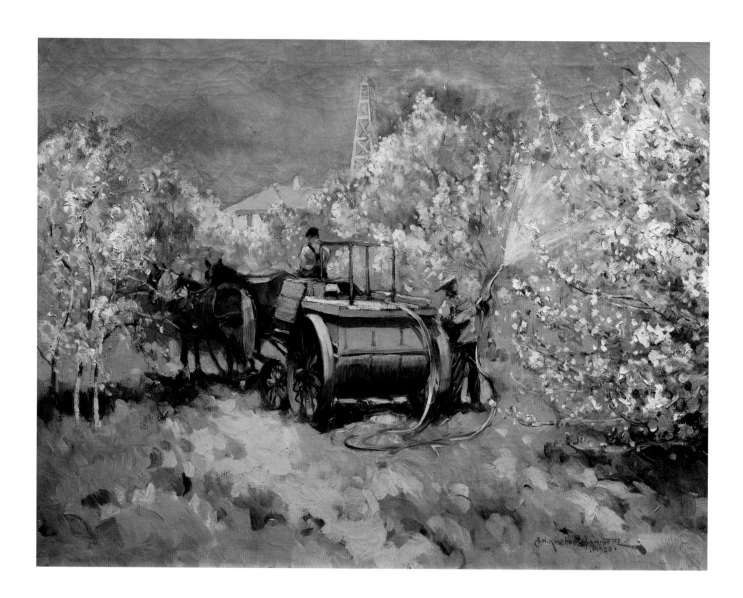

6 **Spraying in H. H. Dow's Apple Orchard with Brine Well in Background** (1920).
 Oil on canvas, 17.75 x 23.5 in.

7　**H. H. Dow's Apple Orchard, Midland, Michigan** (1920).
Oil on canvas, 17.25 x 23.75 in.

32

8 **Part of Cal-Mag Production, Midland, Michigan** (1920).
 Watercolor, 14.25 x 21.25 in.

9 **Epsom Salt Plant, Midland, Michigan** (1920). Watercolor, 14.5 x 18.5 in.

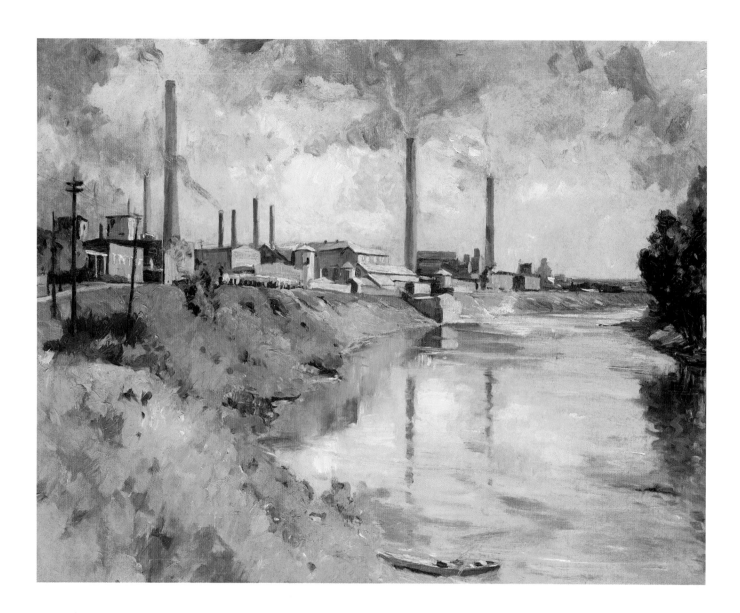

34

10 **Looking Down the Tittabawassee River at the Dow Chemical Plant,**
Midland, Michigan (1920). Oil on canvas, 27.5 x 35.5 in.

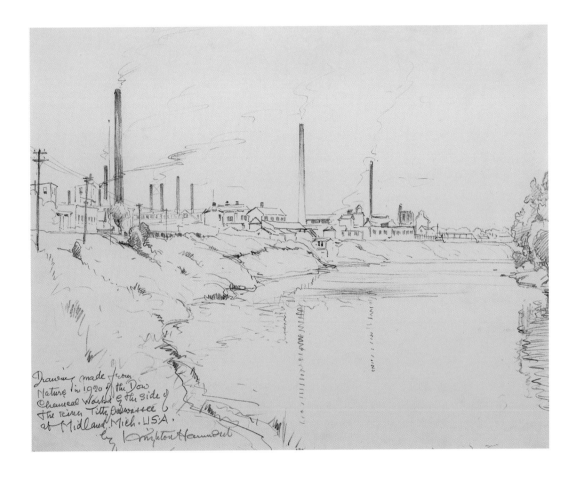

Drawing made from
Nature in 1920 of the Dow
Chemical Works & the side of
the River Titty Dawassee
at Midland, Mich. USA.
by Creighton Hammond

11 **The Dow Chemical Works by the Side of the River Tittabawassee at
Midland, Michigan** (1920). Pencil, 8.5 x 10.25 in.

36

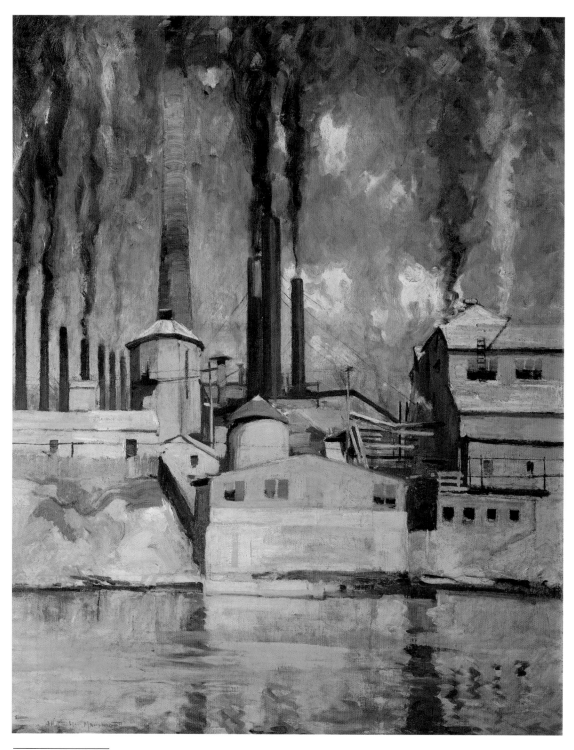

12 **Caustic Pot House Stacks, "A" Power Stack, "A" Pump Station, and "A"
Evaporator Building** (1920). Oil on canvas, 35.5 x 27.5 in.

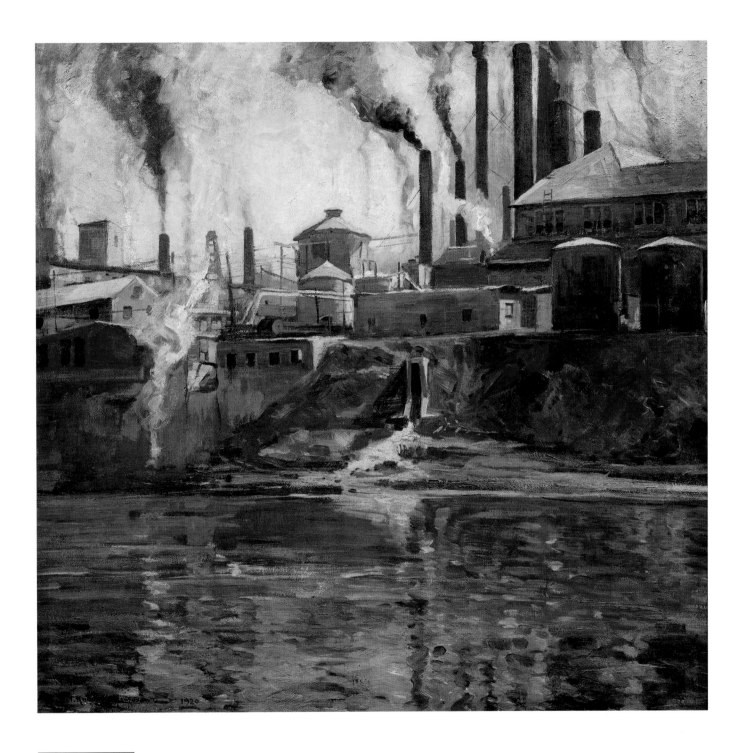

13 **View from the River Showing "A" Power Pump Station and Discharge
Flume** (1920). Oil on canvas, 27.5 x 27.75 in.

38

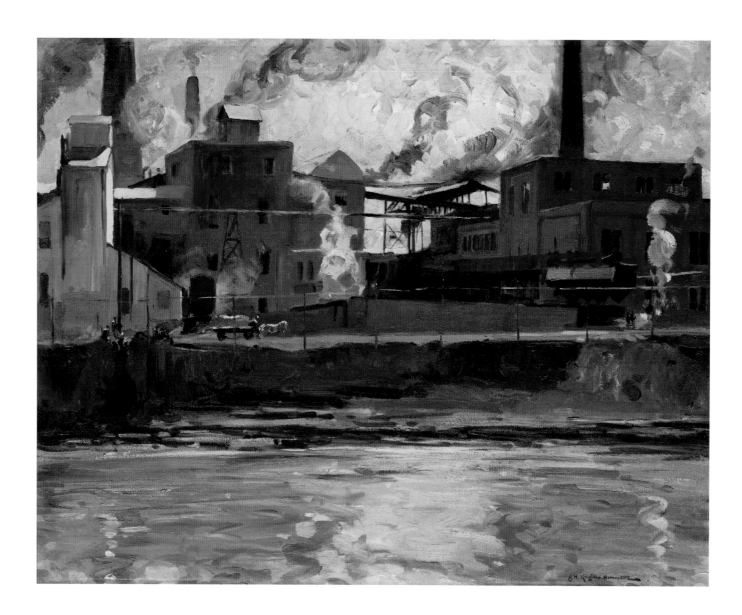

14 **"G" Power House and Caustic Evaporator, Midland, Michigan** (1920).
Oil on canvas, 27.25 x 35.25 in.

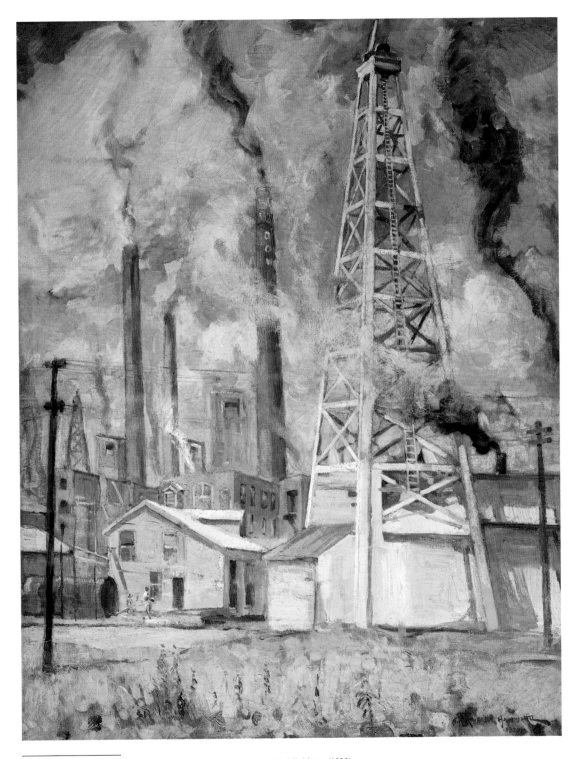

15 **Brine Well with "A" Power House in Background, Midland, Michigan** (1920).
 Oil on canvas, 35.75 x 27.75 in.

40

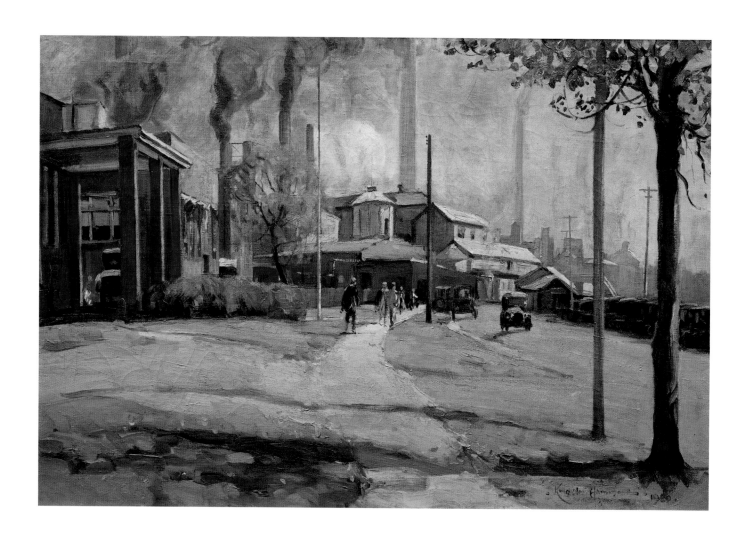

16 **The Dow Chemical Company Main Office Building, Midland, Michigan** (1920).
Oil on canvas, 24.75 x 36.25 in.

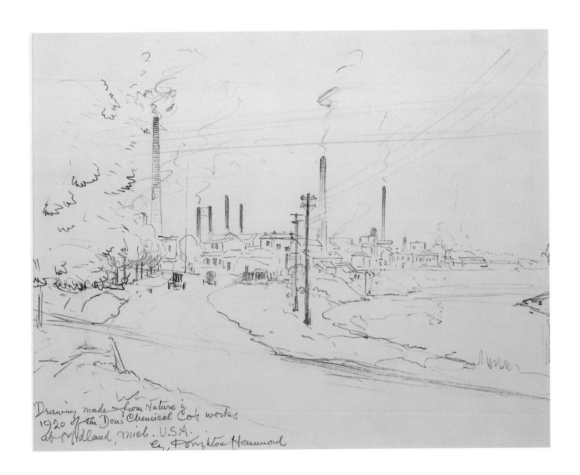

17 **The Dow Chemical Company's Works at Midland, Michigan, USA** (1920).
Pencil, 8.25 x 10.25 in.

42

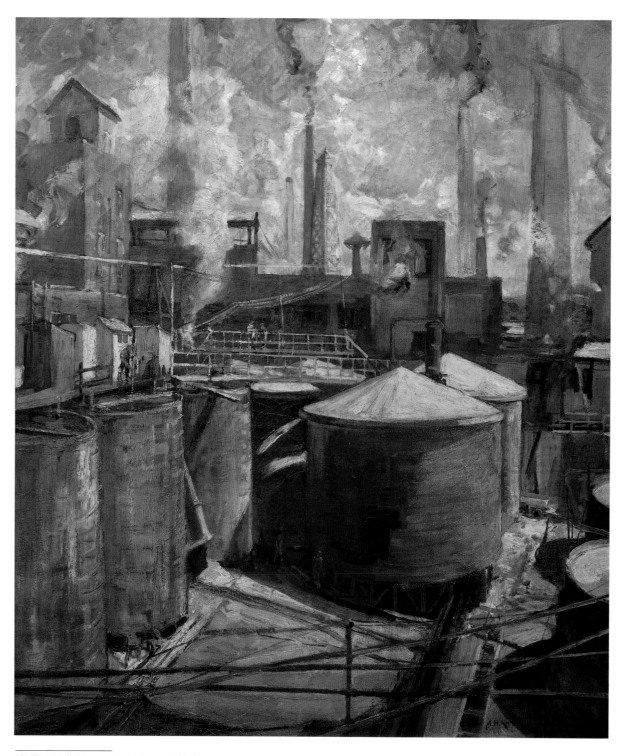

18 **The "Nail" Process Plant, Midland, Michigan** (1920).
Oil on canvas, 29.125 x 24.25 in.

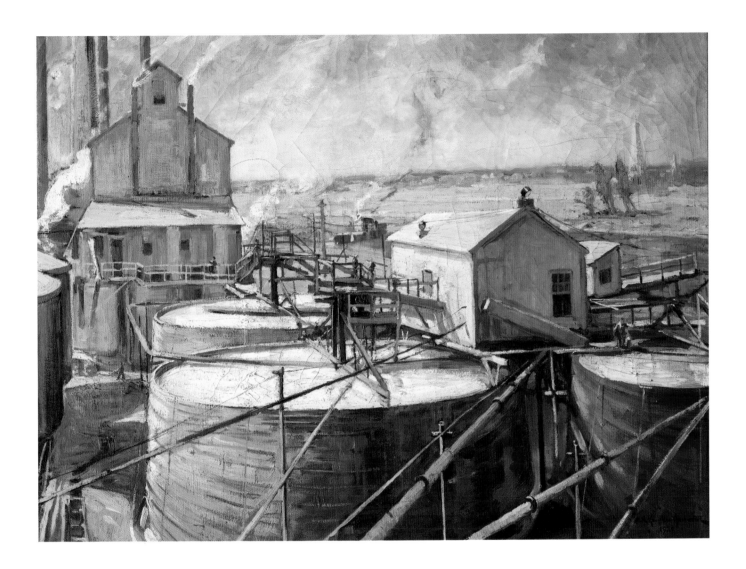

19 **Lime House and Mill** (1920). Oil on canvas, 22 x 30 in.

For Further Reading

"American Chemical Industry." In *Guide to Alpha Chi Sigma* (electronic volume), Indianapolis, 1998 [cited 13 July 1999]. Available from http://www.alphachisigma.org/guide.

Dorothy Dow Arbury. Interview by E. N. Brandt at Post Street Archives, 18 January 1989.

"Art at Bayer in the United States and Europe." *Chemical Heritage, 14:1* (Winter 1996/97), 17.

Laura Rose Ashlee. "Chemistry on Canvas." *Michigan History Magazine,* (July/August 1996), 28–35.

John I. H. Baur. "Beauty or the Beast?—The Machine and American Art." *Art in America*, 48:1 (1960), 82–87.

Ursula Blanchebarbe. "Stadt, Technik und Industrie in der Neuen Sachlichkeit." In *Neue Sachlichkeit; Magischer Realismus.* Edited by Jutta Hülsewig-Johnen. Bielefeld, Germany: Kunsthalle Bielefeld, 1990.

Elisabeth Bott; Uta Miksche; Reiner Ernst Ohle. *KunstWerk: Bildende Kunst bei Beyer.* Leverkusen, Germany: Bayer AG, 1992.

Mary Ellen Bowden. *Chemical Achievers.* Philadelphia: Chemical Heritage Foundation, 1997.

Mary Ellen Bowden; John K. Smith. *American Chemical Enterprise.* Philadelphia: Chemical Heritage Foundation, 1994.

Milton W. Brown; Sam Hunter; John Jacobus; Naomi Rosenblum; David M. Sokol. *American Art.* New York: Harry N. Abrams, 1979.

Francine Carraro. "Oil Patch Dreams: Images of the Petroleum Industry." *American Art Review*, 10:5 (Sept./Oct. 1998), 200–209.

Charles Sheeler. Published for the National Collection of Fine Arts. Washington, D.C.: Smithsonian Publication Press, 1968.

T. J. Clark. *The Painting of Modern Life: Paris in the Art of Manet and His Followers.* New York: Knopf, 1985.

Dow Chemicals. Midland, Mich.: Dow Chemical Company, 1928.

John Gordon. "Exhibition Preview: Business Buys American Art." *Art in America*, 48:1 (1960), 88.

James Hamilton. *Turner and the Scientists*. London: Tate Gallery Publishing, 1998.

Williams Haynes. *American Chemical Industry*. Volumes II and III: *The World War I Period: 1912–1922*. New York: D. Van Nostrand, 1945.

Robert Hughes. *American Visions: The Epic History of Art in America*. New York: Alfred A. Knopf, 1997.

Francis Donald Klingender. *Art and the Industrial Revolution*. Edited and revised by Arthur Elton. New York: Schocken Books, 1970.

John Atlee Kouwenhoven. *Made in America: The Arts in Modern Civilization*. Garden City, N.Y.: Doubleday, 1948.

Karen Lucic. *Charles Sheeler in Doylestown: American Modernism and the Pennsylvania Tradition*. Allentown, Pa.: University of Washington Press for the Allentown Art Museum, 1997.

J. Merritt Matthews. "Art and the Dyestuff Factory." *Color Trade Journal* (1921), 37.

Peter Norris. *Arthur Henry Knighton-Hammond*. Cambridge: Lutterworth Press, 1994.

Miles Orvell. "The Artist Looks at the Machine: Whitman, Sheeler, and American Modernism." *Node9: An E-Journal of Writing and Technology*, 1 (January 1997).

"Painters of Industry." *Fortune*, December 1949, 131–142.

William S. Rodner. *J. M. W. Turner, Romantic Painter of the Industrial Revolution*. Berkeley/Los Angeles: University of California Press, 1997.

" 'A Spirit Striving for Expression,' Knighton-Hammond Paints at Dow." *Chemical Heritage, 13:2* (Summer 1996), 2–4.

"2 NaCl + 2H2O = 2Na(OH) + Cl2 + H2." *Fortune*, April 1931, 58–63, 156–158.

Richard Guy Wilson. *The Machine Age in America, 1918–1941*. New York: Brooklyn Museum in association with Abrams, 1986.